BUILTH WELLS

HISTORY TOUR

First published 2023

Amberley Publishing
The Hill, Stroud,
Gloucestershire, GL5 4EP
www.amberley-books.com

Copyright © Mal Morrison &
Rob Warlow, 2023
Map contains Ordnance Survey data
© Crown copyright and database
right [2019]

The right of Mal Morrison &
Rob Warlow to be identified as the
Author of this work has been asserted
in accordance with the Copyrights,
Designs and Patents Act 1988.

ISBN 978 1 4456 9368 2 (print)
ISBN 978 1 4456 9369 9 (ebook)

British Library Cataloguing in
Publication Data.
A catalogue record for this book is
available from the British Library.

Origination by Amberley Publishing.
Printed in Great Britain.

ABOUT THE AUTHORS

Malcolm Morrison was born and educated in Brecon but has lived in Builth Wells since 1972 and has written extensively about both towns. Most of his working life was spent in healthcare and in teaching and between this his main interests have been the Army Cadet Force, local history matters and spending time with his family.

This book will be the sixth he has produced for Amberley Publishing and the third collaboration with Rob Warlow, the others being *Photographs of Old Builth Wells* (2009) and *A War of Memories* (2012).

Robert Warlow was born and educated in Builth Wells, where he has lived all his life. Working as the finance manager of a local art centre for the last ten years, he discovered a passion for history in his school years and it has been a lifelong preoccupation ever since. This is his third book, all of which have been done in collaboration with Malcolm Morrison.

INTRODUCTION

The market town of Builth Wells is often referred to as the crossroads of Wales as two principal highways, the A470 and A483, intersect here. These are the main arteries connecting the four corners of Wales, so anyone travelling by road from north to south is almost sure to pass through Builth Wells. But do not simply pass by, but linger awhile, because the whole area is steeped in history, some of which dates from Iron Age and Roman times, but it was its castle and market that first made the town what it is.

The town we now know as Builth Wells grew around a motte-and-bailey castle, founded in the twelfth century by Norman invaders to dominate a ford across the River Wye. The area had long been the scene of conflict, and the castle and surrounding lands continued to change hands between the Welsh and Norman lords during the struggle for Welsh independence. It was rebuilt in stone just before the final campaign of Llewelyn ap Gruffydd, the last Prince of Wales, who was killed nearby in 1282, although Welsh resistance and unrest in the area continued until the time of Owain Glyndwr.

The town was granted its charter in 1278, allowing it to hold a weekly market, and agriculture has remained king ever since. Builth was never a walled town like Brecon or Conwy and has suffered from several particularly disastrous fires over the centuries, but somehow it has continually managed to survive and prosper, aided by its idyllic location on the banks of the beautiful River Wye. It was here that Thomas Jones, one of Wales' finest artists, made his home, and here that Buffalo Bill's Wild West made its only visit to mid-Wales in 1904.

The town gained fame during the Victorian era when the taking of spa waters for medicinal purposes became fashionable, resulting in 'Wells' being added to its name, and while the spas no longer draw visitors, the suffix remains to remind us of its proud heritage. Times change, and after the largest agricultural

show in Europe, the Royal Welsh Agricultural Show, made its permanent home here in 1963, it helped to ensure Builth's future. Builth has become a popular tourist destination and the fortunes of the entire district are very much in the ascendancy. Now visitors mainly tend to come to participate in one of the many outdoor activities on offer in the area, be it fishing, horse riding, cycling and mountain biking, or simply to enjoy walking peacefully through the stunning beauty of the local countryside.

It is still true to say that all roads lead to Builth, but the infrastructure is changing. The population has remained almost static since 2001, which in the year 2020 was estimated to be a little over 2,600: 1,351 females (51.4 per cent) and 1,276 males (48.6 per cent). Christianity is the religion followed by 64 per cent of the population with a surprising 35 per cent claiming not to follow any religion. The balance was made up of nine Buddhist, three Muslim and fifteen with other religious beliefs. The above figures include the Llanelwedd parishes*.

Twenty-first-century Builth has so much to offer: delightful places to stay and dine, a cheerful high street with a variety of interesting shops to browse, and cafés to rest and chat with friends. But it is the people who make it unique. Friendly and welcoming is how they like to think of themselves. This little book sets out to take you on a trip around Builth's streets and thoroughfares, pointing out interesting bits of history and making the reader more aware of what this little gem in the beautiful Wye Valley was, and what it still has to offer.

*UK Office for National Statistics

Mal Morrison and Rob Warlow, 2023

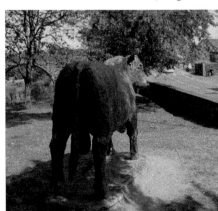

The Builth Bull.

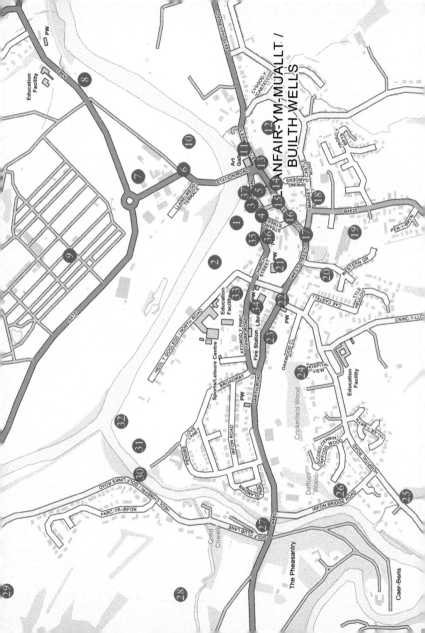

LLANFAIR-YM-MUALLT /
BUILTH WELLS

KEY

1. Builth Bridge
2. The Groe
3. Groe Gates
4. Duck Lane
5. Groe Street
6. Station Road
7. Builth Station
8. Station Yard
9. Royal Welsh Show
10. Bridge from Llanelwedd
11. Wyeside
12. The Castle
13. Broad Street
14. Lower High Street
15. Middle High Street
16. Upper High Street
17. West End
18. Bank Square
19. The Cattle Market
20. Smithfield Road
21. St Mary's Church
22. Garth Road East
23. Garth Road West
24. The Hospital
25. Nant yr Arian
26. Irfon Bridge Road
27. Irfon Bridge
28. Glanne Wells
29. Park Wells
30. Irfon Suspension Bridge
31. The Pump Track
32. Aber Pool
33. North Road
34. Park Road
35. Alpha and the Gorsedd Stones
36. Strand Street
37. The Builth Bull

1. BUILTH BRIDGE

The iconic Wye Bridge from the banks of the Groe (*Gro* meaning 'pebbles' in the Welsh language). The walk along the riverbank is delightful in all seasons and the view towards the bridge is one of the town's most photographed scenes. The bridge was once a very narrow affair, and many a panicking steer or fat lamb met an untimely end by jumping over the parapets during the crush whilst being driven to market. The bridge was widened in 1925 to accommodate modern traffic.

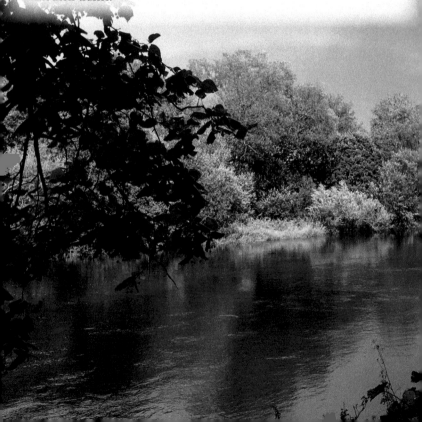

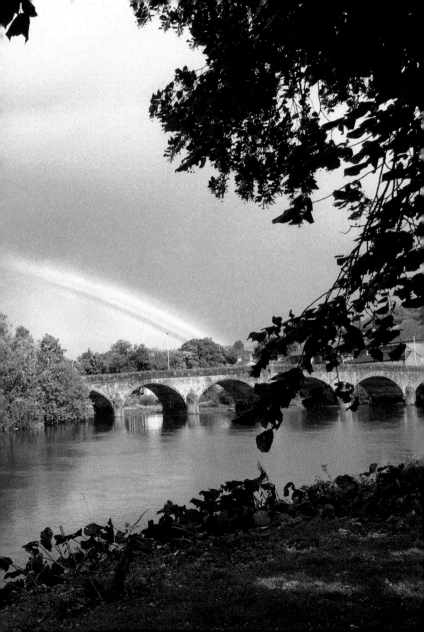

2. THE GROE

A rare photograph taken before the avenue of trees was planted. Abram Davies of the Builth Wells Urban District Council was the prime mover for the establishment of the beautiful avenue during the Edwardian era. The avenue became known as 'Abram's Folly'.

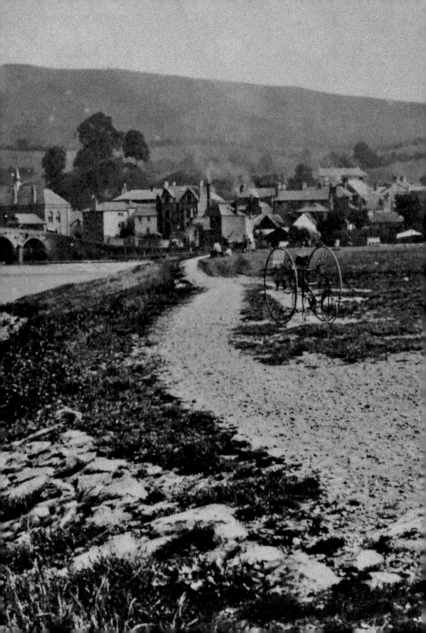

Here we see the trees in their infancy, *c.* 1914. One of the iconic Wellingtonias can be seen in the background and local tradition has it that they were a gift from Buffalo Bill when he visited in 1904. Who knows, but the age is about right. The trees themselves were planted by W. H. Weatherley & Son, Nurserymen of Hay Road. The first planted were the Wellingtonias, which dominate the entrance today.

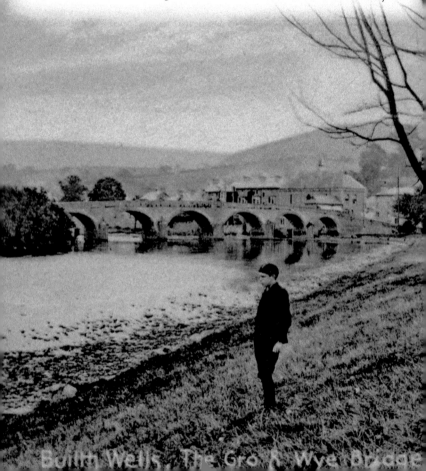

Builth Wells, The Gro & Wye Bridge

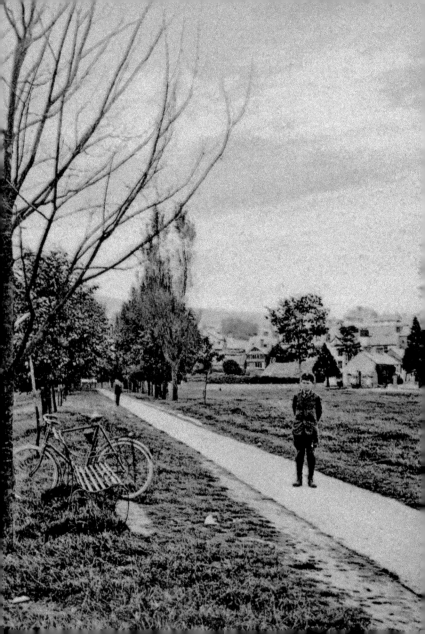

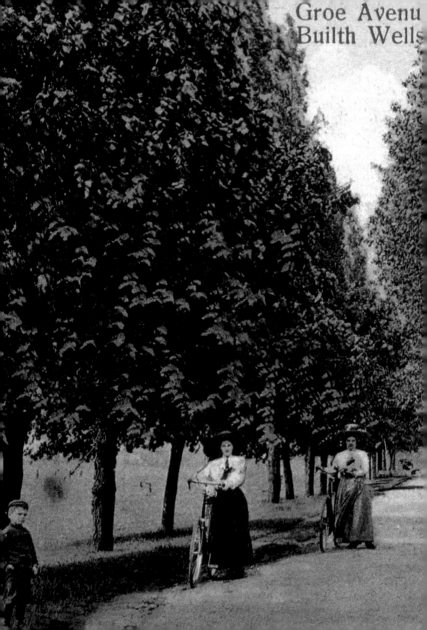

Groe Avenu
Builth Wells

The Groe, *c.* 1925, looking upstream. Instantly recognisable, the avenue is now well established, and sheep are still being grazed here. The ladies look very elegant alongside their bicycles; their large hats and long skirts were, it seems, deemed suitable attire for lady cyclists back in the day.

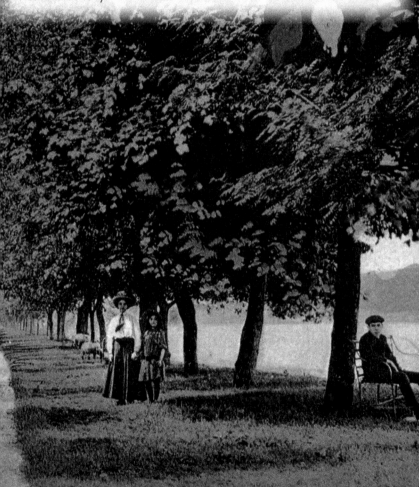

3. GROE GATES

An early view of the very ornate Groe Gates and a Wellingtonia tree. This photograph predates the War Memorial, which was dedicated in 1926. The gates were relocated some distance upstream near the Bowling Green in order to widen the park entrance following the appearance of the motor car. The stone pillars, dated 1873 and 1905 respectively, are all that remain at the original location.

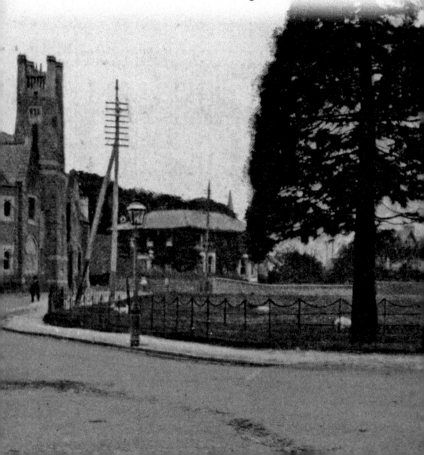

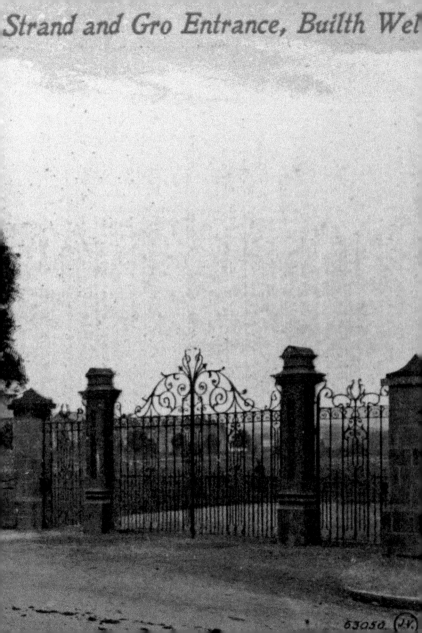
Strand and Gro Entrance, Builth Wel

4. DUCK LANE

This picture, taken from a magic lantern slide, shows a cattle sale taking place near the area of today's War Memorial looking towards the town. The large building in the background is easily recognisable and has changed just a little. However, the row of cottages are gone and today the area forms part of a hotel car park.

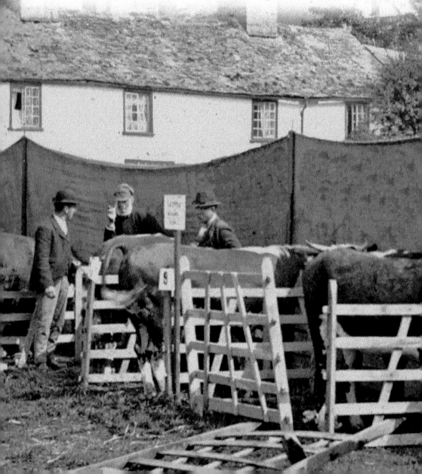

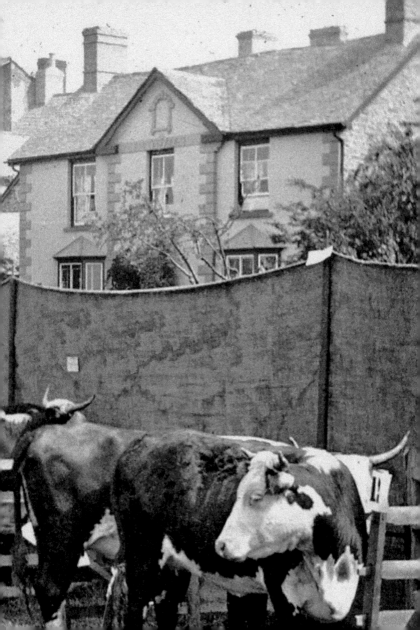

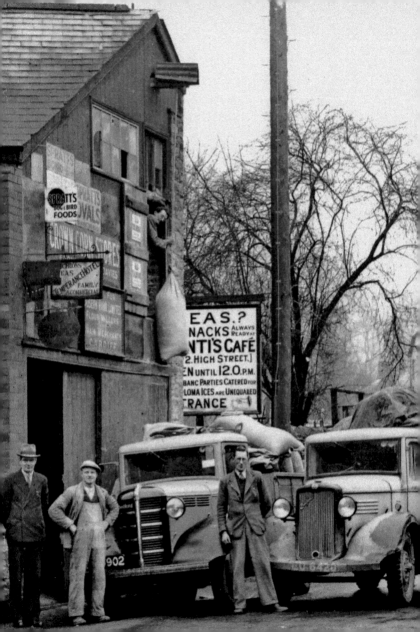

5. GROE STREET

Before we cross the Wye Bridge to Llanelwedd, take a look at the buildings in Groe Street near the bridge. This was once a commercial area where a blacksmith plied his trade at the back of the Fountain Inn (reputedly the town's oldest inn), and a farmer's cooperative traded from the building that once was the Crown Hotel. The Crown was the town's premier hotel but the building is long gone, replaced by a bank, which incidentally is the town's last remaining bank (in 2023).

6. STATION ROAD

We cross the Wye Bridge into the village of Llanelwedd, which remains a predominantly commercial area. The recaptured steer had probably escaped from a nearby abattoir; the nearby building was the popular Llanelwedd Stores, which was demolished fairly recently to make way for a supermarket and petrol station. The building beyond was originally the Station Hotel. It became residential properties soon after the railway closed.

This photograph of Builth Cycling Club was taken on the opposite side of the road near what is now the entrance to a builder's merchants, which occupies much of the old station yard.

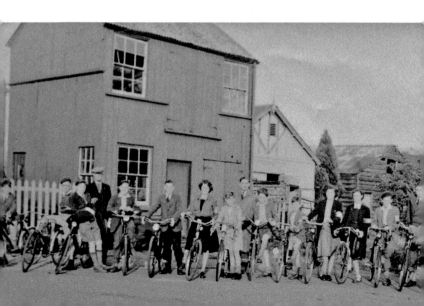

7. BUILTH STATION

A steam train leaving Builth station on what was the Cambrian Railway, heading in the direction of Rhayader. The inset shows *Venus*, the first train to arrive at the new Builth Wells station in 1860. The line ran between Brecon and Moat Lane Junction (Caersws) and was closed in 1962.

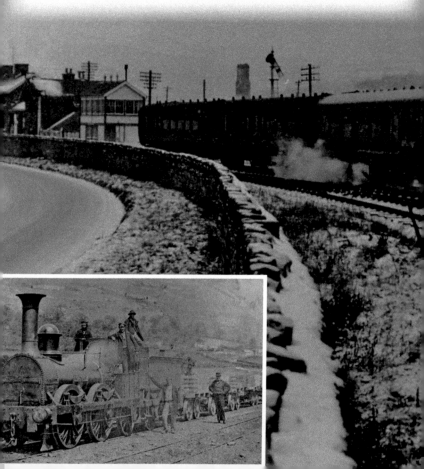

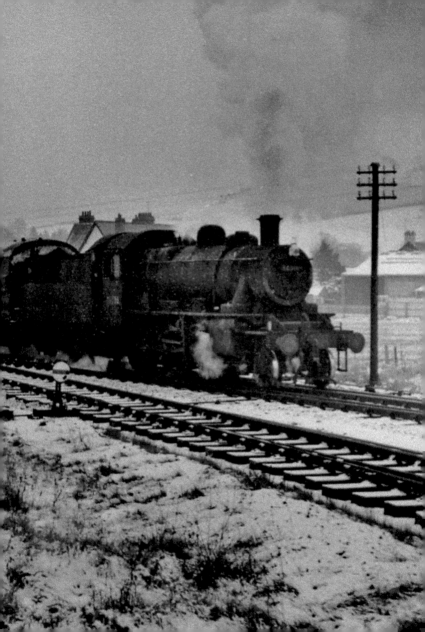

8. STATION YARD

A view looking across St Matthew's Church, Llanelwedd, towards the busy station yard and the town beyond. The photograph, by P. B. Abery, shows in some detail just how busy the station yard once was. The line closed in 1962 and very little evidence of its existence remains. The track nowadays forms part of cycle route 8. The walk or cycle along its length as far as the old quarry workings about a mile away gives some very rewarding views.

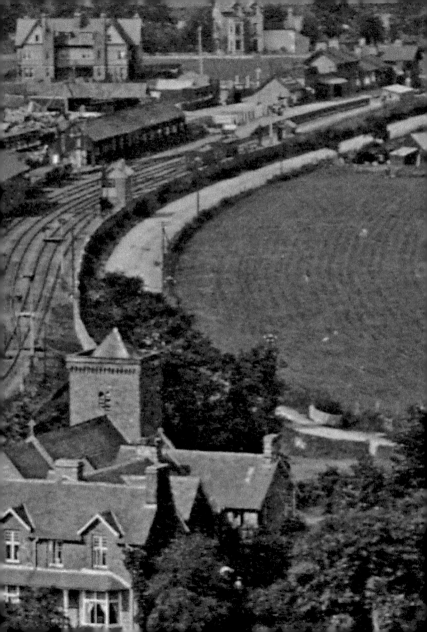

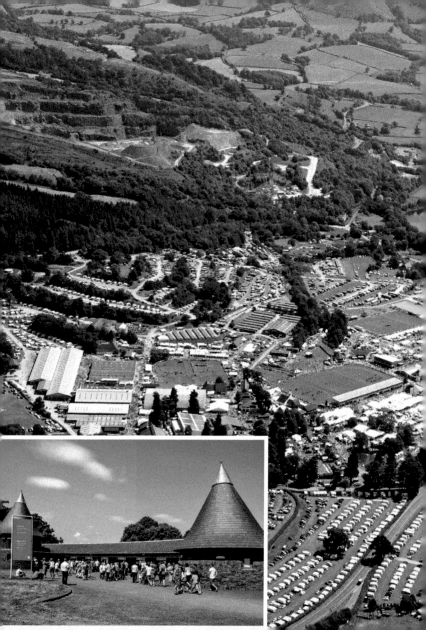

9. ROYAL WELSH SHOW

The Royal Welsh Show first came here in 1951 and made Llanelwedd its permanent home in 1963. Since then it has grown to become the largest agricultural show in Europe, regularly attracting a quarter of a million visitors over four days. Builth Quarry can be seen in the background. Stone from here built the Elan Valley dams. Inset: The Showground entrance.

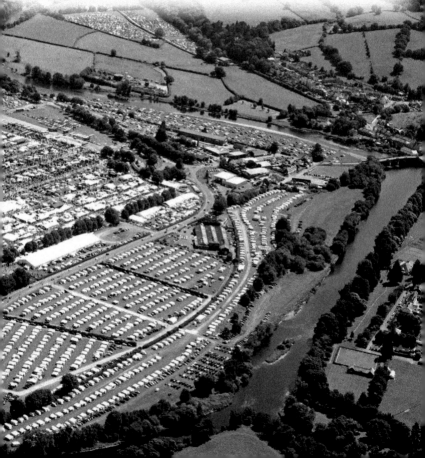

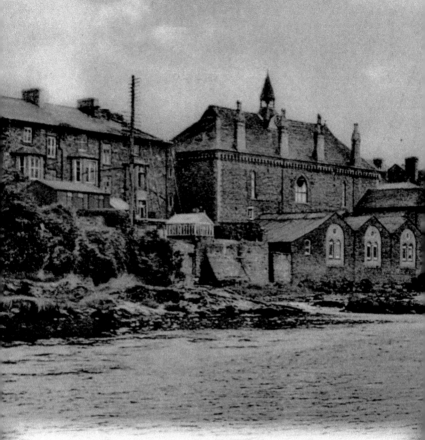

10. BRIDGE FROM LLANELWEDD

The Wye Bridge from Llanelwedd. The bridge was built in 1779 and widened in 1925 when it became unsuitable for modern traffic. The large building, built in 1877, started its life as a concert and market hall before becoming a cinema (The Kino and later the Castle Cinema), until its conversion in recent times into the fine cinema/theatre complex known as Wyeside Arts Centre.

THE TOWN BRIDGE, BUILTH WELLS

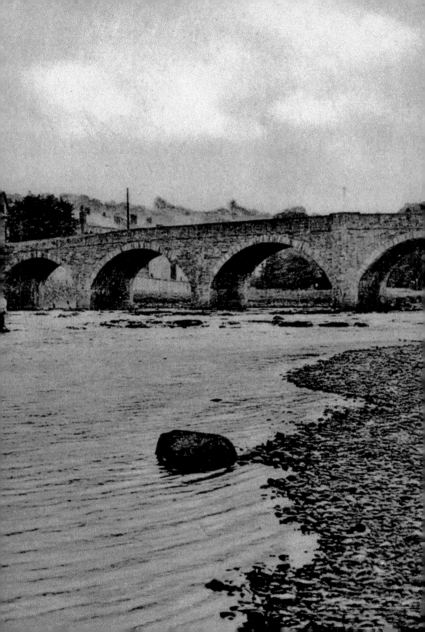

11. WYESIDE

These two views show the area formerly known as Lion Square prior to the demolition of the small cottages and the farm buildings to construct the beautiful building that became Wyeside Arts Centre. The photographs are poor quality and have suffered water damage but enough remained to give us a good indication of how the area looked in 1862.

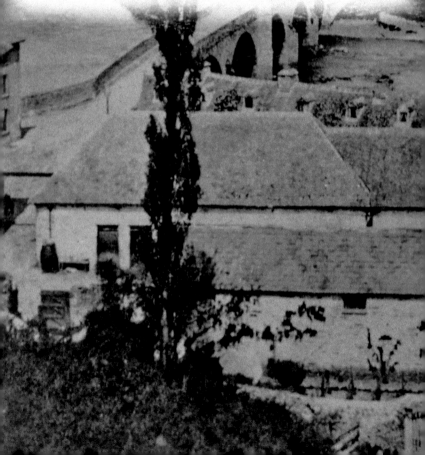

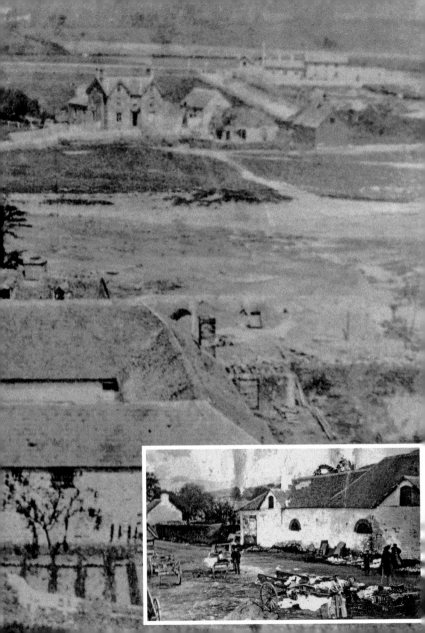

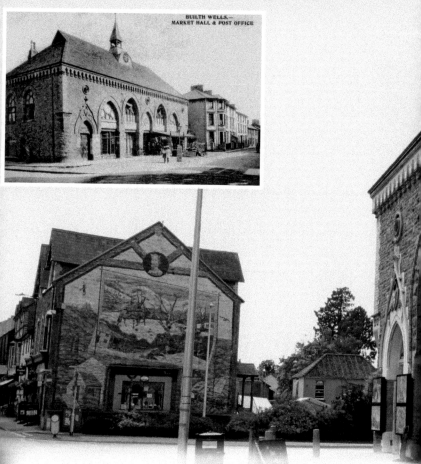

A lovely view of the front of the Wyeside Arts Centre looking towards the town's Broad Street. The mural is probably the first sight that greets visitors and travellers to the area. It tells an improbable version of the story of the killing of the last Prince of Wales near Builth Wells in 1282. The inset shows an interesting view of how the Arts Centre building looked back in the day.

12. THE CASTLE

The earliest castle appeared here in the twelfth century. Captured and destroyed by the Welsh, it was rebuilt in stone in the thirteenth century. Small compared to the North Wales castles, its design was innovative. It fell into disuse during the sixteenth century. All that remains today are formidable earthworks overlooking the town. Materials from the decaying castle were very probably used to rebuild much of the town following a disastrous fire in 1690.

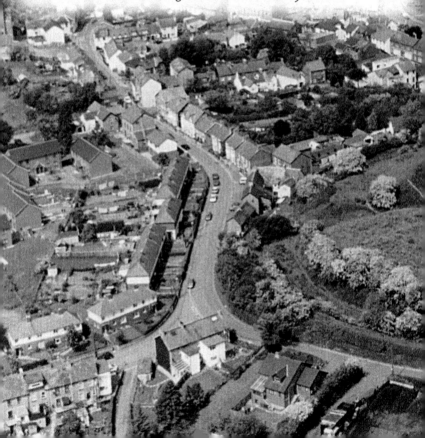

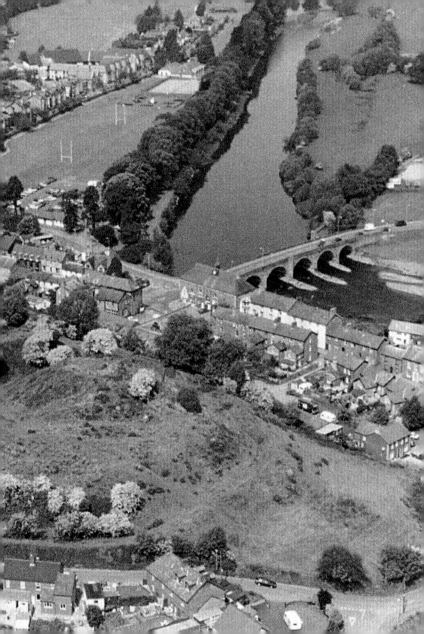

Designed by master castle builder James of St George, the outer defences appear to cleverly funnel attackers into designated killing zones. The plan shows the stonework we are confident of, but we are uncertain about the defences on the western side, although we feel this weaker side would have been adequately protected. Monks from Brecon Priory were entitled to dine here after singing mass, and we read that they made good use of the privilege.

LEGEND

Shell Keep/Keep	✦
Gatehouse and Drawbridge	⧉
Walls of Bailey	▬
Possible outer Wall	– ⋅ – ⋅ –
Possible Site of Towers	●
Possible Wooden Tower and Footbridge	⊂●▬
Possible Wooden Palisade	⬤⬤⬤⬤
Possible Wooden Defended Gate	⊂●▬●⊃
Wet Ditch	▼▼▼▼ / ▲▲▲▲
Embankment	▲▲▲▲ / ▼▼▼▼
Denotes Slope, Wide End is Top of Slope	▼

LINE OF CASTLE

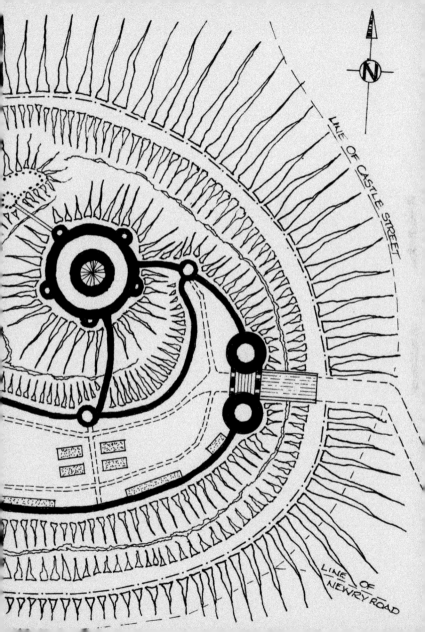

LINE OF CASTLE STREET

LINE OF NEWRY ROAD

13. BROAD STREET

Broad Street has undergone many changes over the years. It was originally the widest street in the town, but a huge fire in 1907 resulted in much of the north side of High Street being destroyed and subsequently widened. This view looking east along Broad/High Street shows clearly the uniform width resulting from the fire; the canopies have gone but the buildings remaining have changed little.

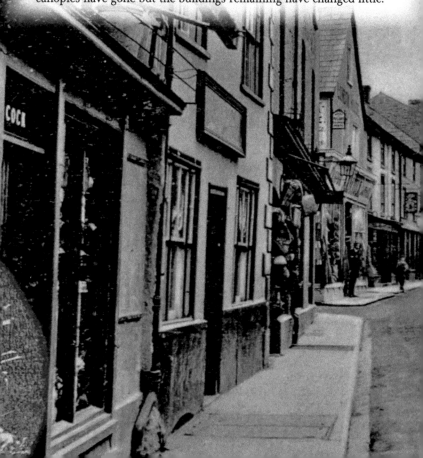

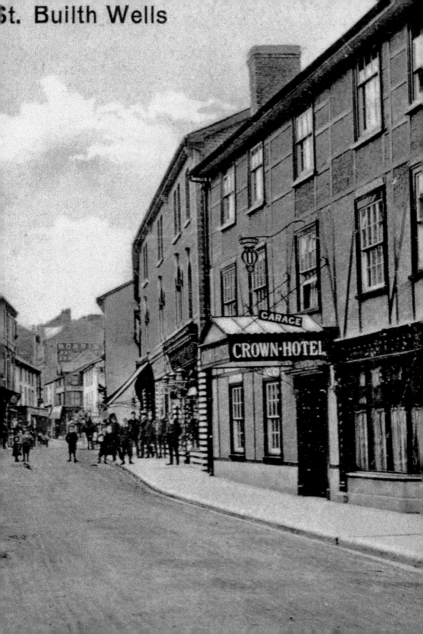

14. LOWER HIGH STREET

The spot where Broad Street becomes High Street used to mark a narrowing of the street, as seen here. The fire of 1907 destroyed all the shops on the right side, allowing the street to be widened considerably.

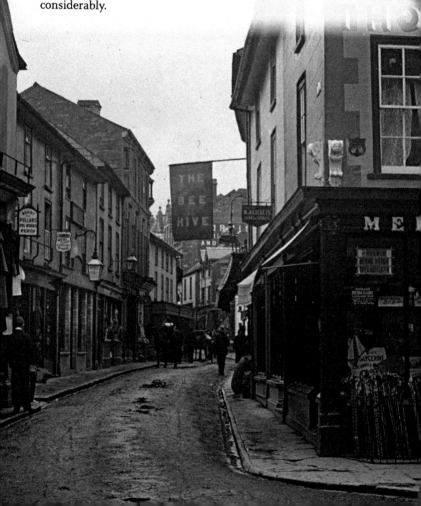

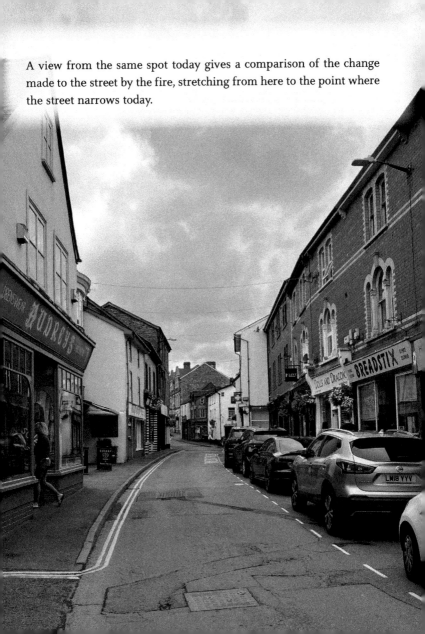

A view from the same spot today gives a comparison of the change made to the street by the fire, stretching from here to the point where the street narrows today.

15. MIDDLE HIGH STREET

An early photo of Builth High Street, giving a glimpse of the shops and showing how few changes there have been to this part of the street. One part that has changed, however, are the shops just below this section (right of the picture, just below the horse and cart), where the buildings were destroyed by a fire in 1928 and later built further back from the street in their current location.

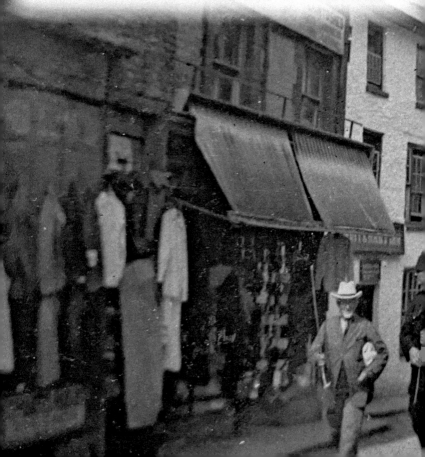

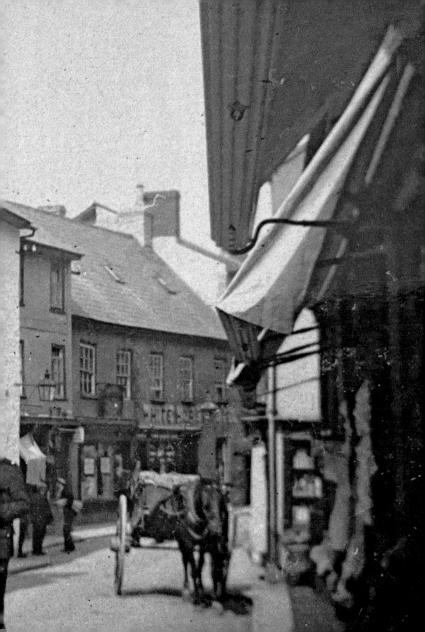

Builth has been a market town since 1278, but until the current market was opened all animal sales took place on the streets of Builth. As seen here, cattle were sold along the High Street, a less than ideal situation for many reasons, not least the mess underfoot! As can be seen, the animals were not penned or corralled, just left to roam free.

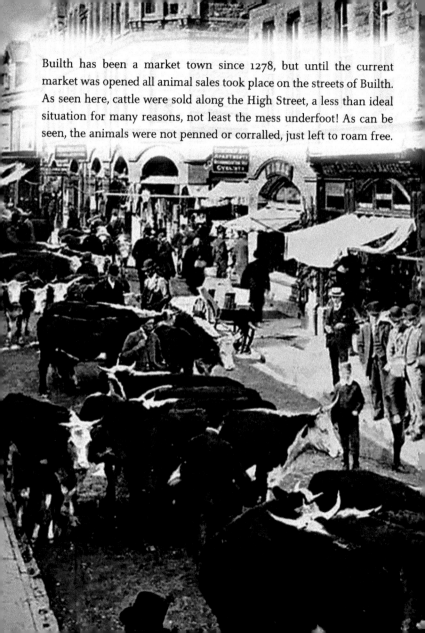

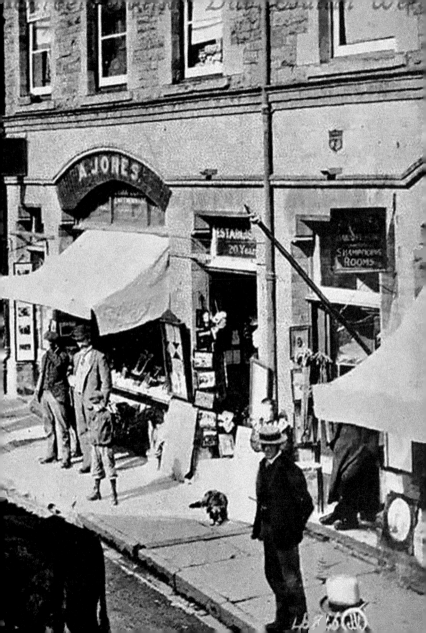

16. UPPER HIGH STREET

This scene of local business at work serves as a good reminder of the importance to the region of a market town. This was not just a place to sell animals but was also a place for people from the surrounding area to come and buy whatever goods and services they might need, from birthing shawls to funerals.

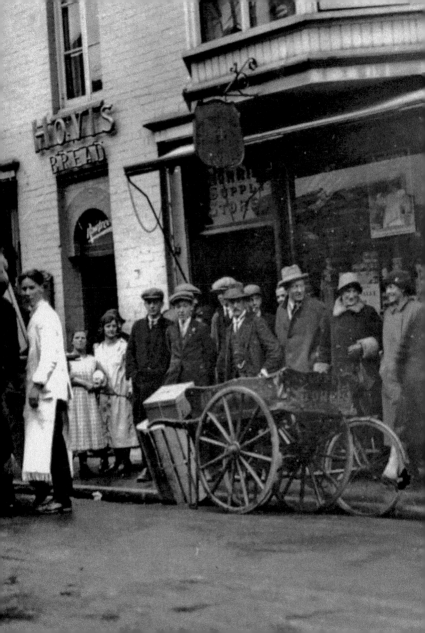

17. WEST END

Leading on from the High Street, West Street was the site of two public houses (of which there were seventeen in the town of Builth in 1860). These were an important place to do business, especially the sale of sheep and cattle, which was conducted inside the various pubs. The small shop on the left still retains one pushed-in window, a reminder of the time a bull in the street leant against it!

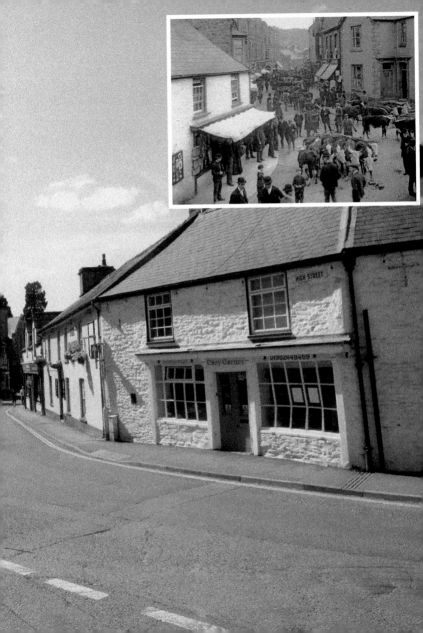

18. BANK SQUARE

Although small, Bank Square was one of the main areas for sheep sales prior to 1910, as well as home to thirty-two families and businesses. Ruth or 'Cobbled' Lane as it was known connected the square to the main street and is still an experience to descend. The big brick building (left of inset) was the site of the Baptist chapel for many years, with the version seen here dating to the 1840s.

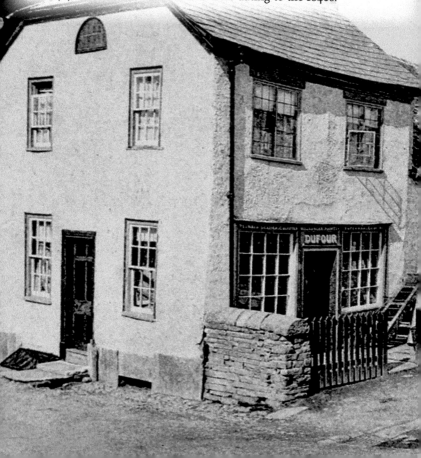

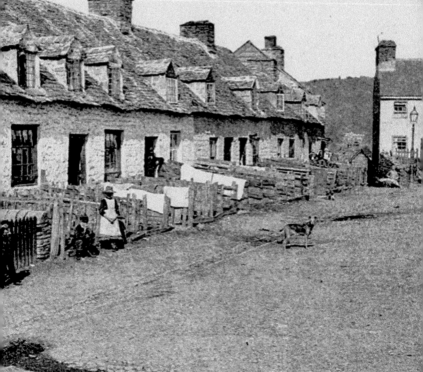

While the cattle market was originally held on the High Street, sheep sales were held along nearby Market Street and on Bank Square (as seen here). As can be seen, sheep pens were attached to local houses, meaning they would be right outside the front door of residents of the square!

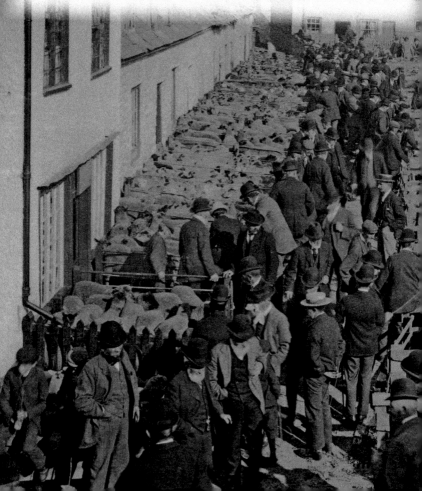

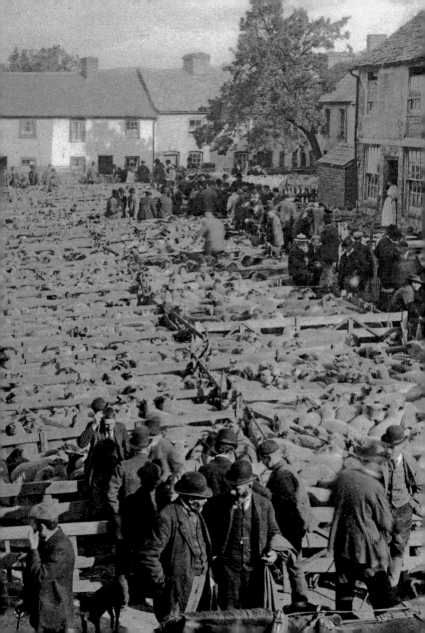

19. THE CATTLE MARKET

Stretching from Smithfield Road to Brecon Road, the current cattle market was opened in 1910 and has been in weekly use ever since. Selling both sheep and cattle, it was for many years the driving point behinds the town's economy.

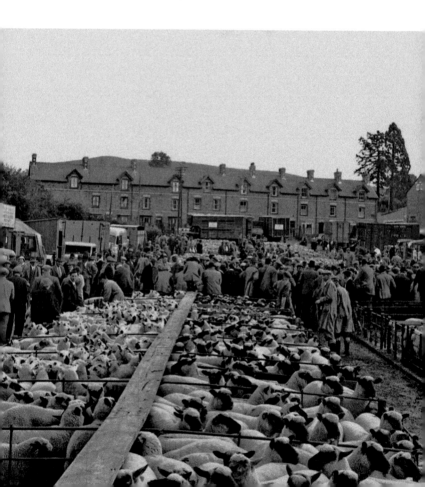

These photos, dated to the 1950s, gives an idea of the organised chaos surrounding a busy market day and the sort of characters one might see there. Market day was about more than just business, being a social occasion for local farmers in the area.

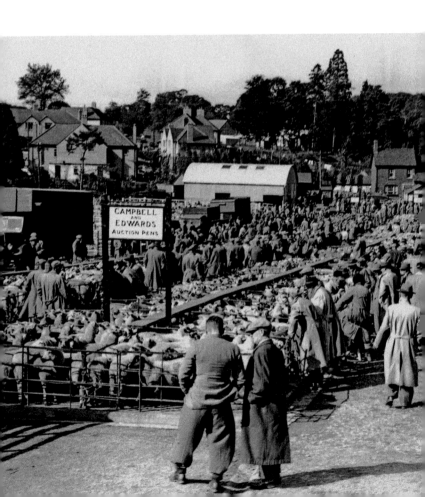

20. SMITHFIELD ROAD

Although one of the shortest roads in the town, Smithfield Road has been an important road over the years. As well as being one of the entrances to the town's cattle market, it was the site of the local Drill Hall for the Builth militia company (the brick building on the left), and the site of the first fire station (on the right) with the horse stables for the fire engine just below it.

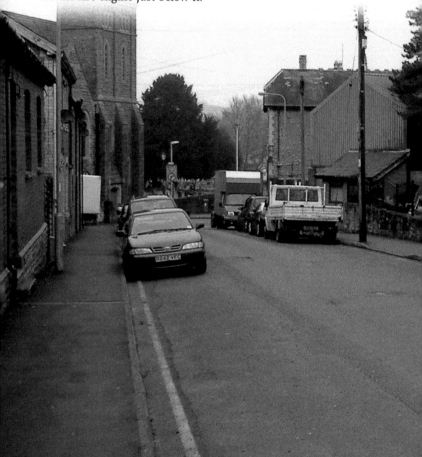

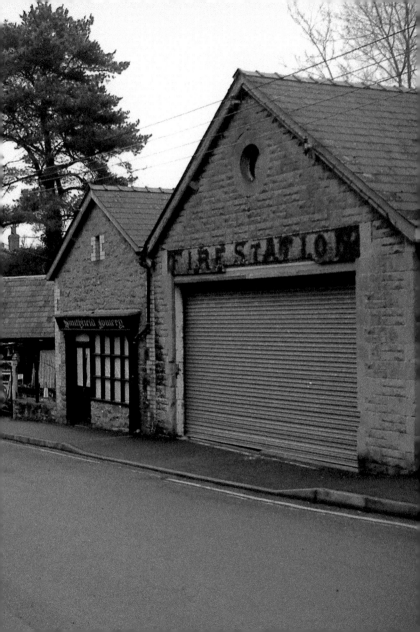

21. ST MARY'S CHURCH

The current St Mary's Church, located in the centre of town, was opened in 1875. However, the tower is much older, dating to the late fourteenth century, and there has been a church on this site since at least 1283. Inset is the earlier church that occupied the same site (on the opposite side of the tower) and outside the front of which John Wesley preached in 1743.

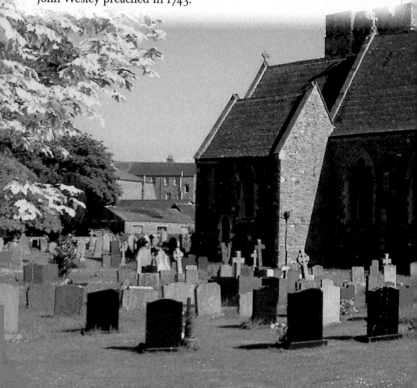

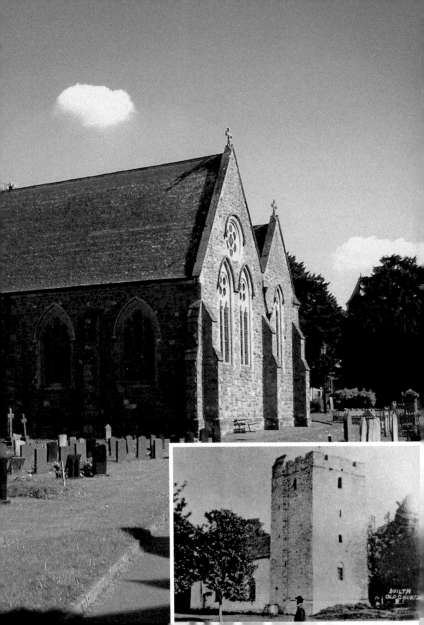

BUILTH
OLD CHURCH

22. GARTH ROAD EAST

Garth Road looking west towards the medicinal wells. Garth Road was one of the streets built in response to the growing wealth of the town created by visitors coming to visit the town's spas. As can be seen in this picture, it wasn't just shops that helped provide that wealth, with a bread merchant and a knife sharpener's carts providing their services on the street.

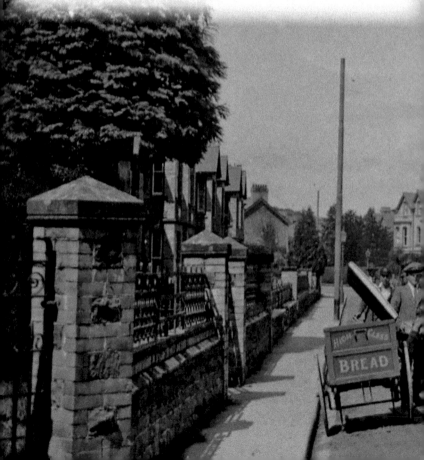

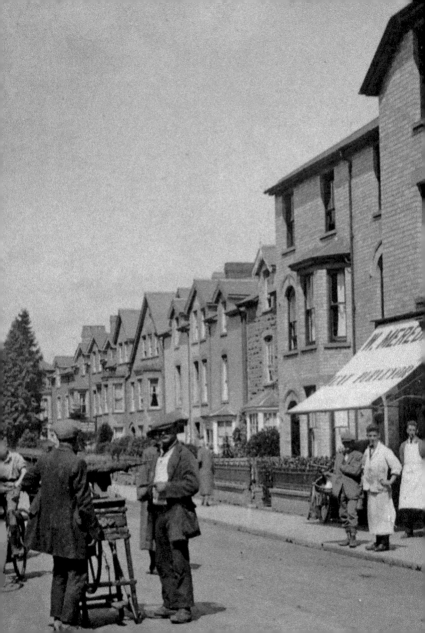

23. GARTH ROAD WEST

Garth Road as seen looking east, with the appropriately named Garth Hill in the background. The hill is a dominating landmark around Builth and can be seen from most of the town. It is also a popular walk for locals and visitors alike.

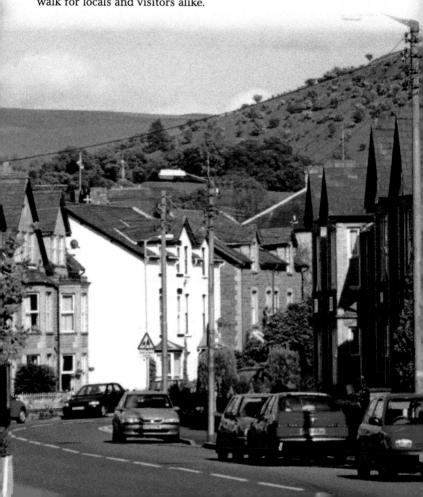

24. THE HOSPITAL

Builth Cottage Hospital was opened in 1897 and was built in isolation on top of the hill to keep it away from the damp river mists, although over the years the town grew up around it. Unfortunately, the hospital was closed in 2013, with a modern housing estate replacing it. However, one of the blocks of houses was constructed as a reminder of the building that once stood here (inset).

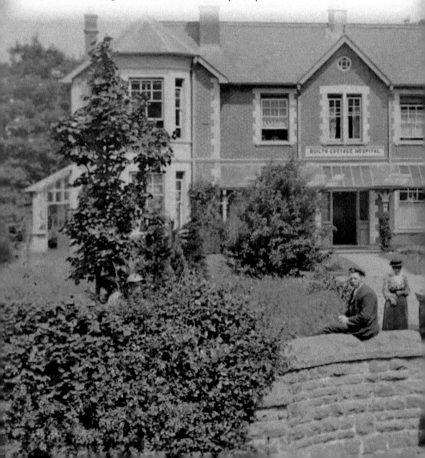

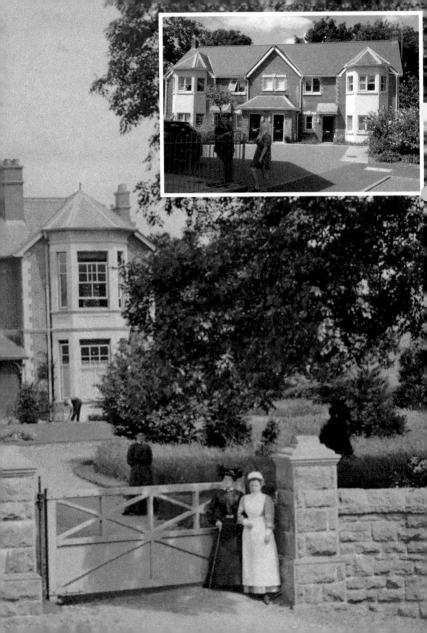

25. NANT YR ARIAN

Nant yr Arian – its translation means 'The Silver Stream' – is a small row of cottages on the edge of town. The name allegedly comes from the time of the plague, when farmers coming to trade with the townspeople would have them throw their money into the stream to wash it first. At the top end of the cottages was a blacksmith's forge, with a mill situated at the bottom end of the lane.

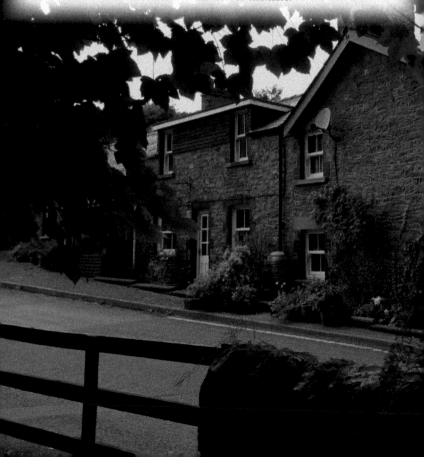

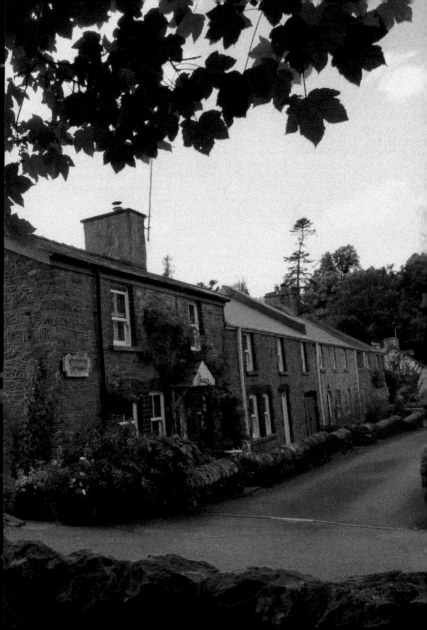

The site of one of several blacksmiths in Builth, this was the forge at Nant yr Arian. For an agricultural area with the widespread use of horses both on farms and as transport, the town's blacksmith provided a vital function.

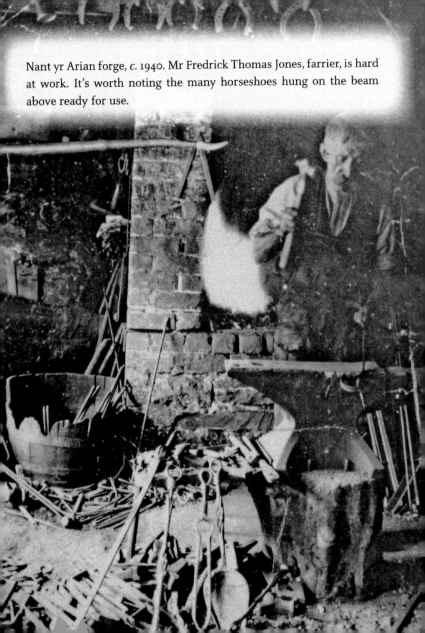

Nant yr Arian forge, *c.* 1940. Mr Fredrick Thomas Jones, farrier, is hard at work. It's worth noting the many horseshoes hung on the beam above ready for use.

26. IRFON BRIDGE ROAD

Running from Nant yr Arian down to the Irfon Bridge, the view of Irfon Bridge Road has changed considerably from this photo over the years, with many houses and housing estates being built in this area, and even the bridge itself being rebuilt. However, it remains one of the more picturesque parts of the town, and a lovely road to stroll along.

27. IRFON BRIDGE

The current Irfon Bridge was opened on 30 November 1937, replacing the more scenic, but less practical original stone bridge (inset). Built *c*. 1785, the old one proved too narrow for modern traffic being only a single vehicle wide. Although the current bridge itself is perhaps not as scenic, its surroundings are still just as charming, and it remains part of Builth's beautiful 'Three Bridges Walk'.

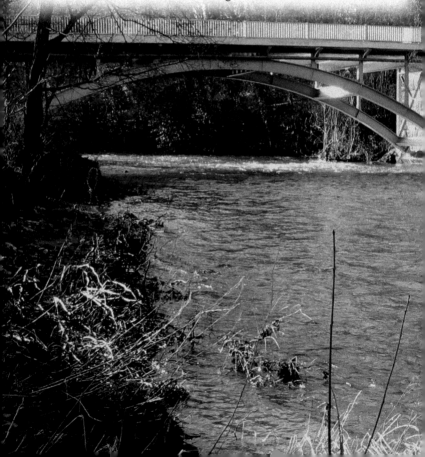

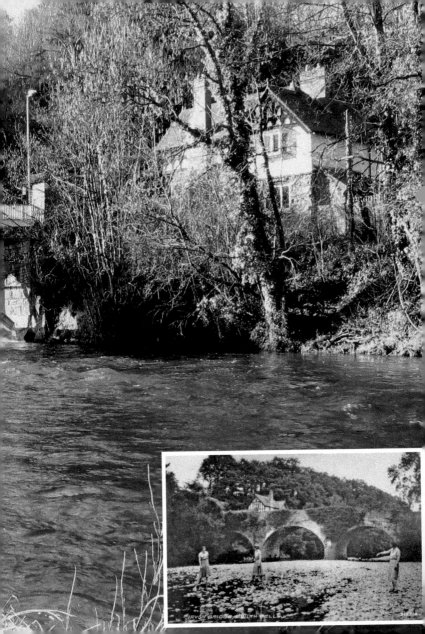

IRVON BRIDGE, BUILTH WELLS

28. GLANNE WELLS

'It tastes strong of sulphur and smells much like gunpowder.' This early description of the waters from Glanne Wells may sound unappetising, but it was the popularity of the mineral springs at Builth that gave a major boost to the town in the nineteenth and early twentieth century. The area is now a part of Builth's eighteen-hole golf course.

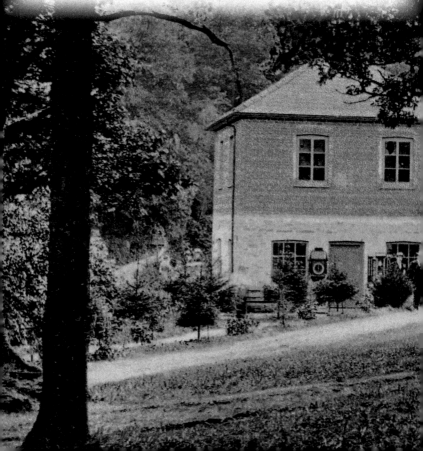

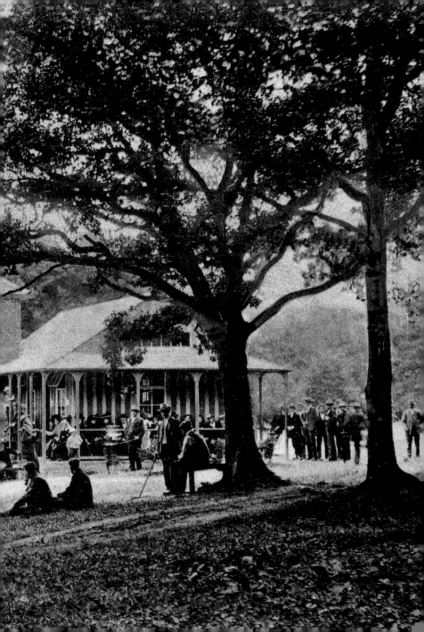

29. PARK WELLS

The spring at Park Wells was discovered in the 1830s and was considered one of the best saline springs in the country. The round building in the centre is the pumphouse around the spring. Most people would walk up here from the town to 'take the waters', although it was later possible to get the water bottled from the boathouse on the Groe. The buildings still exist but are now a private dwelling.

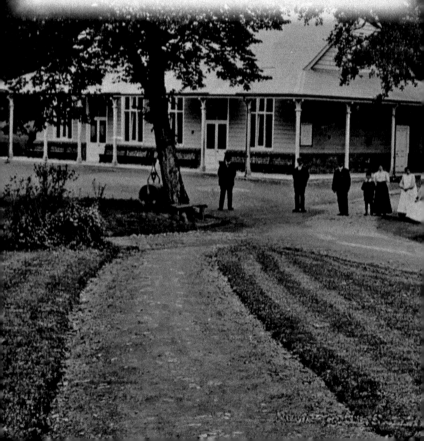

30. IRFON SUSPENSION BRIDGE

The Irfon Suspension Bridge – better known as Swing Bridge to locals due to its sway when crossing – originally spanned the River Usk. Upon being moved to Builth to provide better access to Park Wells it was found to be too short, so another piece was added from the stone upright to the bank.

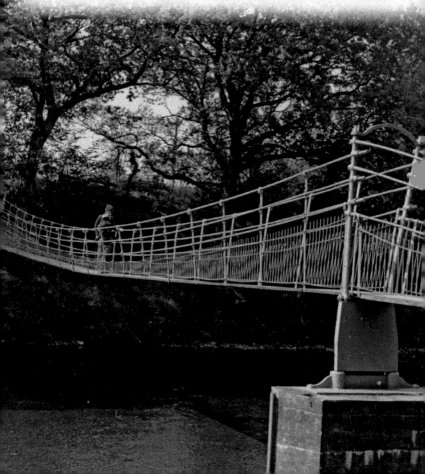

The old Swing Bridge was replaced with the current one in 1984, with the new one being a raised arch to prevent the river flooding over the bridge and damaging it, as used to happen regularly with the old bridge. The surrounding area has long been a favourite play area for local children.

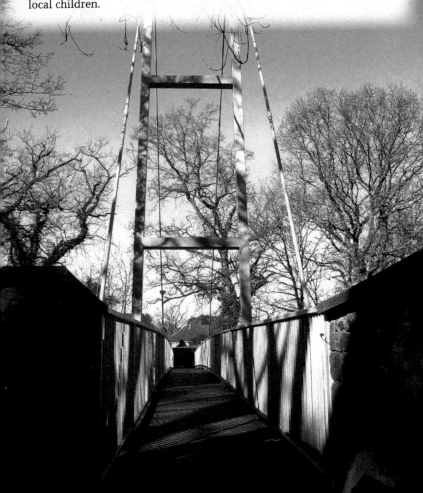

31. THE PUMP TRACK

A recent addition to Builth's park can be seen here in the shape of the new pump track, added in 2022, and a reminder that Builth is still a modern, growing town.

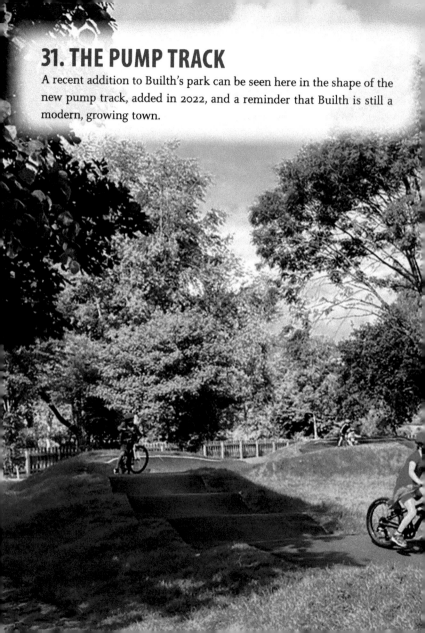

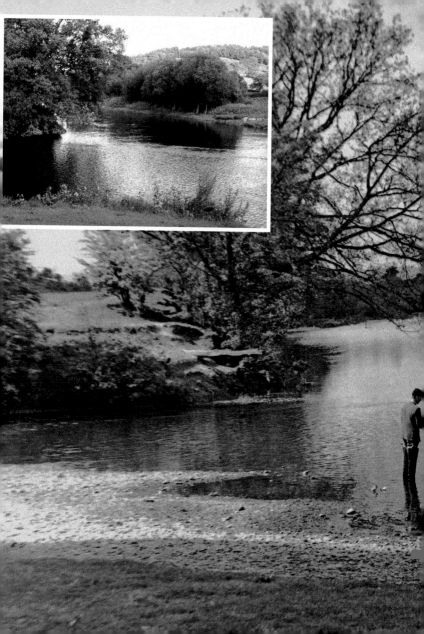

32. ABER POOL

Aber Pool is the point where the River Irfon joins the River Wye. It was a popular place for swimming and diving – in the early photo the diving board can be seen on the far bank (centre left) – and is still a popular fishing site. The modern photo shows the same view today, still a lovely spot to relax and enjoy the view.

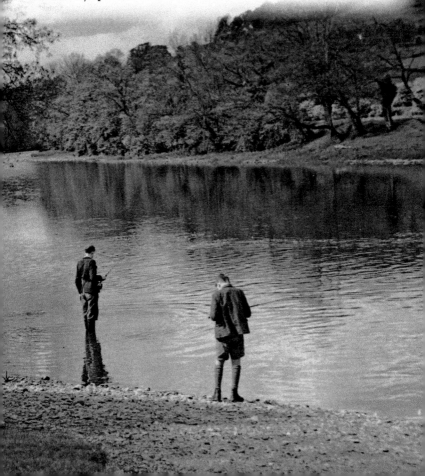

33. NORTH ROAD

This view of the Groe dating to the early part of the twentieth century also shows the unpaved North Road, another of the streets built in Builth's spa era. Much of the western side of town was created during this time.

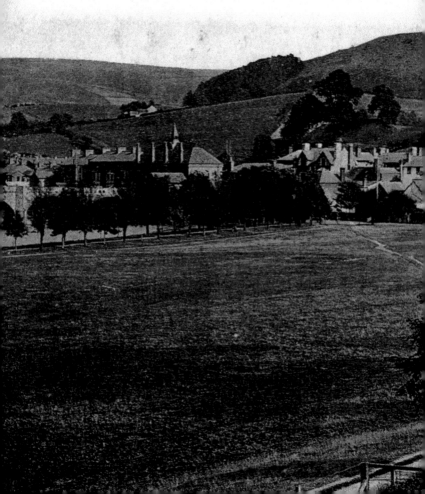

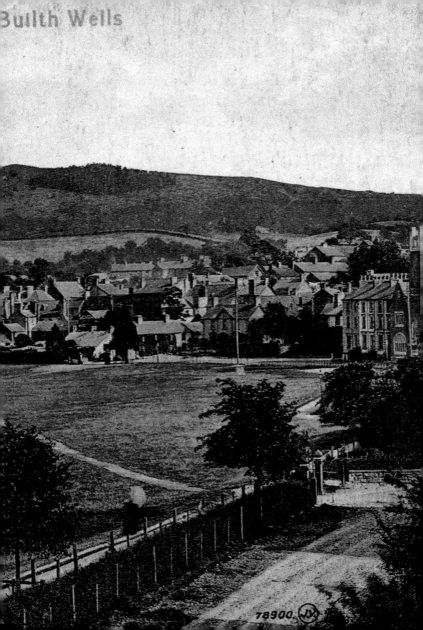
Builth Wells

34. PARK ROAD

Another of the streets built in the heyday of Builth's spa era, Park Road was originally the site of Builth's Primary School before it was moved to Hospital Road, with the old school building being renamed Antur Gwy and now serving as the town library and local government offices. The street is also the site of Builth's High School, which was first opened here in 1899 but completely rebuilt in the 1980s.

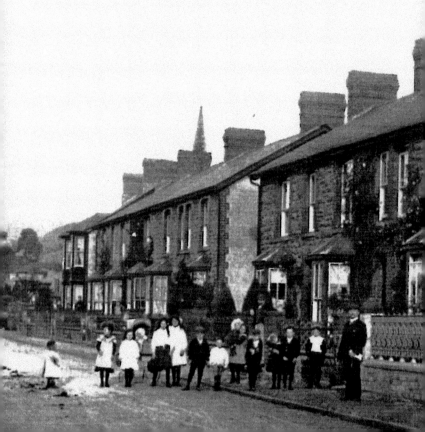

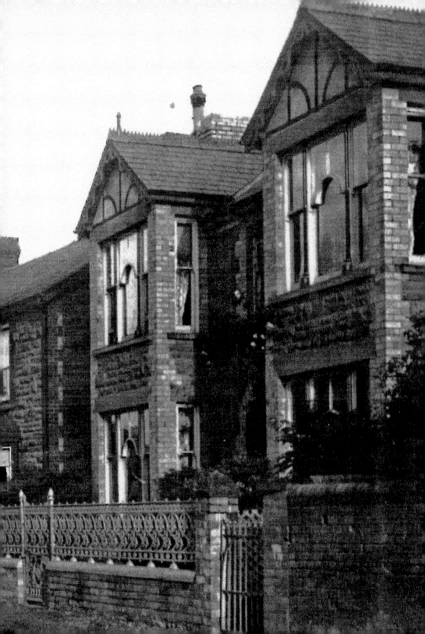

35. ALPHA AND THE GORSEDD STONES

Situated at the end of the Groe is Alpha Presbyterian Chapel, the third such chapel built here to bear the name. This late Gothic-style building was constructed in 1903. Opposite on the Groe the Gorsedd Stones can be found, erected to commemorate the visit to Builth of the Welsh National Eisteddfod in 1993.

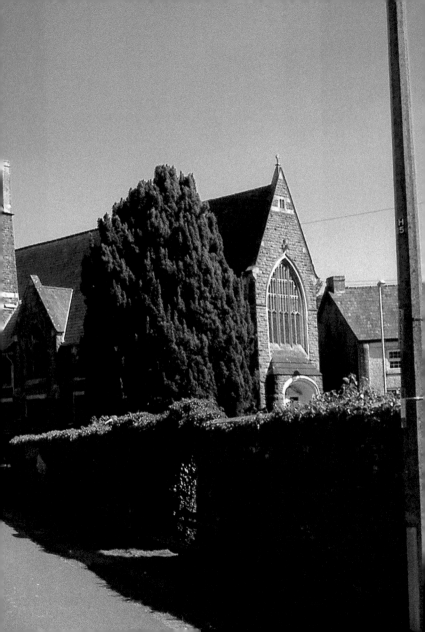

36. STRAND STREET

Strand Street, leading from the High Street to the Groe, holds two historic buildings. On the right is the arched entrance to the Strand Hall, built by Squire Bligh as a community hall in 1876. Opposite it is the old Post Office, unusual in being built in 1936, making it one of only three built during the reign of Edward VIII.

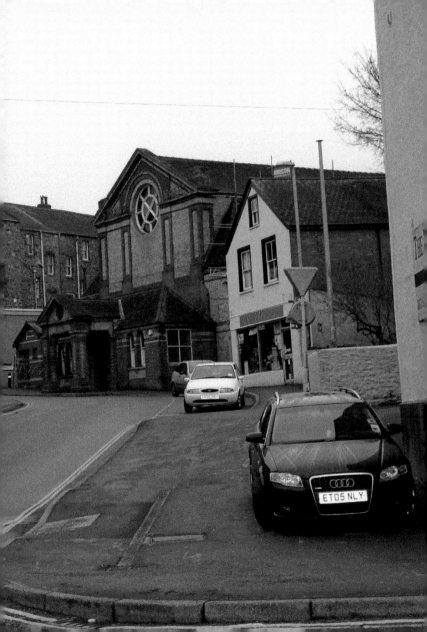

37. THE BUILTH BULL

Unveiled in 2005, this life-sized statue is a fitting place to end our tour of Builth. The Welsh name for Builth, Llanfair ym Muallt, translates as 'The Church of Saint Mary in Buallt' (Buallt mutating to Muallt), with Buallt meaning 'ox pasture'. Buallt later became anglicized to Builth, with 'Wells' being added after the discovery of the spas. Thus, the image of the Welsh Bull has become a fitting icon for this important agricultural town.

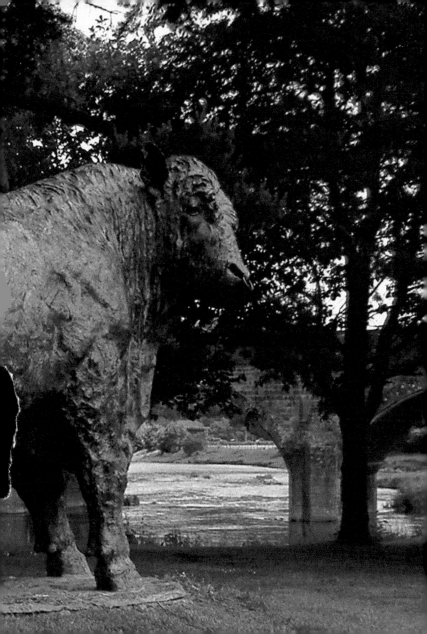

ACKNOWLEDGEMENTS

We would like to thank the Builth Wells and District Heritage Society for access to their vast photo library, and all the kind people who have allowed us to use their great photographs including Laura Wilson and Van Rhijn Aerial Photography for the wonderful picture of the showground; Ruth Hargest for her photo of Garth Hill; Andrew 'Wil' Williams once again for his outstanding help and countless hours spent preparing the plan of Builth Castle; Laura Chorman for sending her late husband Bob's photo albums from the USA – we wish we could have included more; our friend Ted Edwards for his photo of the Showground entrance; and of course to Amberley Publishing, who conceived the idea for this book and have supported us throughout.

Whilst every effort has been made to ensure accuracy and to gain permissions for the pictures used, for any error or omission we can only offer our sincere apologies and we will make the necessary change at the first opportunity.